McArthur
3-1-88

D0600363

JUDITH GOLDEN

Cycles, A Decade of Photographs

Untitled 45

The Friends of Photography

San Francisco, California

With thanks to my parents,
Dorothie and Walter Greene,
for their support, and to
my children, David and Lucy,
for their patience. J.G.

Front cover: *Cycles I, 1984—1985*
Back cover: *Cycles III, 1984—1985*

© 1988, by The Friends of Photography
Photographs © 1988, by Judith Golden
Essay © 1988, by Claire V. C. Peeps

ISSN 0163-7916; ISBN 0-933286-47-3
Library of Congress Catalogue No. 86-82516

All rights reserved in all countries. No part of this book may be reproduced or translated in any form without written permission from The Friends of Photography.

UNTITLED 45
This is the forty-fifth in a series of publications on serious photography by The Friends of Photography. Some previous issues are still available. For a list of these write to Publication Sales, The Friends of Photography, 101 The Embarcadero, Suite 210, San Francisco, California 94105.

THE FRIENDS OF PHOTOGRAPHY
The Friends of Photography, founded in 1967 in Carmel, California, is a not-for-profit membership organization with headquarters in San Francisco. The programs of The Friends in publications, grants and awards to photographers, exhibitions, workshops and lectures are guided by a commitment to photography as a fine art, and to the discussion of photographic ideas through critical inquiry. The publications of The Friends, the primary benefit received by members of the organization, emphasize contemporary photography yet are also concerned with the criticism and history of the medium. They include a monthly newsletter, *re:view,* the periodic journal, *Untitled,* and major photographic monographs. Membership is open to everyone. To receive an informational membership brochure, write to the Membership Director, The Friends of Photography, 101 The Embarcadero, Suite 210, San Francisco, California 94105.

Judith Golden's name is known and respected by her peers within the photographic community. After more than a decade of active work in the medium, it is appropriate that her images receive the widespread recognition that her accomplishments deserve. Since the beginning of her photography career in the mid-1970s, Golden has devoted her energy to the development of her work and to teaching. In 1977, The Friends had the pleasure of offering Golden early recognition by including her in the traveling exhibition *Emerging Los Angeles Photographers*. In 1985, she was an instructor for The Friends' summer workshop *Facing The Camera: The Photographic Portrait*. Golden is a dynamic and perceptive teacher, and it was no surprise that workshop students felt she provided one of the most intense educational experiences offered in the program. In early 1987, an exhibition of her newest photographs was shown in The Friends Gallery in Carmel. We are pleased that we are able to bring Golden's important and innovative photography to the attention of a much broader audience through this issue of *Untitled*.

Cycles, A Decade of Photographs demonstrates the range and depth of both Golden's growth and her exploration of the medium. It is appropriate that the volume begins with the early *Cycles* series and ends with a reconceptualization of similar ideas in her most recent work, which is again entitled *Cycles*. This return to the past relates to formal devices the photographer uses in constructing her unique pieces. Golden applies material objects and drawing techniques to the surface of a print, and recycles and recontextualizes such elements as magazine covers, movie posters, neckties and miniature toy airplanes. Although these methods are being explored by a growing number of photographers, Golden must be seen as one of the forerunners in incorporating popular cultural imagery within photographic images. *Cycles, A Decade of Photographs* reflects the artist's creative concerns and processes while it celebrates her personal approach to the medium.

Thanks must first go to Judith Golden for her selfless support, cooperation and assistance throughout the project. Also gratefully recognized is Claire V. C. Peeps, for her perceptive introduction, and for her preparation of the chronology. Additional thanks go to James L. Enyeart, for his work on the informative interview with the artist. On the staff of The Friends of Photography, acknowledgement is given to Linda Bellon-Fisher, Lorraine Nardone, Sylvia Wolf and John Breeden, for their editorial assistance. Thanks are also due to John Bailey, Gloria Bernat, Richard Fraoili, David Golden, Dorothie Greene, Maureen Murdoch, Lucinda Rizzo, the Tucson Museum of Art and the Museum of Photographic Arts in San Diego for allowing us to reproduce works from their collections; and to Michael Mabry and Sarah Keith, for creating the beautiful design of the book and shepherding it through production.

Publication of this book was aided by a generous grant from the Visual Arts Program of the National Endowment for the Arts, a Federal agency.

David Featherstone, Editor
The *Untitled* series

by Claire V. C. Peeps

What distinguishes Judith Golden as a portraitist is her conviction that we are not the individuals we appear to be. The masks we wear in daily life—our cosmetic covers and the appointments of our rank or trade—have been the sources of Golden's imagery for more than a decade. While the general purpose in portraiture has been to identify some revealing quality of gesture or facial expression that captures the sitter's soul, Golden's quest has been to identify the chameleon in each of us, to recapitulate our most common guises. She has divulged our secret but collective desire to play out the roles of sweetheart, seductress or corporate officer through a donning of a mask, and has revealed our deep ties to a communal consciousness.

Not only has Golden explored the demeanor of contemporary fashion, but she has also been captivated by the fictionalized faces of Hollywood and Broadway, as well as by the ceremonial masks of other cultures. Her investigations of each of these have resulted in major bodies of work. In the self-portraits Golden made during the 1970s, she demonstrated our tremendous susceptibility to the influence of mass-media imagery. These early photographs suggested that we have adopted the social facades created by the mass media to fulfill certain stereotypical roles. Gradually, Golden's use of a contemporary, media-defined mask has evolved to a reflection of the mystical and psychic powers attributed to masks in primitive and ancient cultures. In Golden's current work, the *Cycles* series (plates 28–32, cover, back cover), the masks used in various Native American rituals have inspired an exploration of the cycles of life and death, the passage or suspension of time and a communing with the earth's elements. A determining factor in this evolution was brought about by her 1981 move to the Southwest, where she currently resides.

Golden lives on a four-acre plot of land located near Tucson, Arizona. The view from her adobe home is bound by the Catalina Mountains to the north and the Tucson mountains to the west. At night, her living room window becomes a stage for the whole of the Southwestern sky, and in the morning the same proscenium reveals a spectacular expanse of saguaro, brush and prickly pear. It is at once a rich and hostile landscape, an arid stretch of earth that is the grand but temperamental host to an extraordinary array of desert wildlife.

The long history of Native American culture is closely tied to this land; the earth's seasons and natural forces figure prominently in the annual rituals of the region's various tribes. During the past five years, Golden has observed many Native American ceremonies such as the Snake Dance of the Hopi, the Easter festivities of the Yaqui and the Shalako ceremonies of the Zuni. Golden has become interested in how the masks of paint and mud applied to the dancers' faces in these celebrations serve an integral function in a process of spiritual transformation. While she has not wished to incorporate the specific symbolism of Native American mask-making in her work, she has adopted the idea of the mask as a vehicle for the expression of intense, internal experience and has borrowed some of the formal techniques of face-painting in her *Cycles* series.

The *Cycles* photographs are made in the desert landscape outside Golden's studio, where, against a backdrop of dry grass and cactus, she creates a living collage. First she applies paint or mud to the model's face. Dirt or water may be added in smears or strokes, and layers of leaves, sticks and bits of cactus needle are placed carefully around the figure. When she is satisfied with the arrangement, Golden makes an exposure in the camera. This process of active camouflage may then be continued in the studio by drawing with pens or markers on the developed transparency, or by applying paint to the surface of the print. The twenty by twenty-four-inch image is completed with the construction of a mixed-media frame that extends the photograph's illusions by adding real objects to the surrounding surface. Shadows cast across the model's face in the photograph may be duplicated by a blade of real grass accurately attached to the frame to cast the same shadow. Leaves sprout from these constructions, and twigs lie as if trampled underfoot. In the finished piece, the figure is at last completely embedded in the environment, united with the earth's elements and in harmony with its powers.

This process of assembling materials, and of applying color to the surface of the print, is not new to Golden's photography. Even in her earliest series, which was completed in 1972 and was also called *Cycles*, Golden color-toned her black and white prints to render them in muted, pastel hues. Her images were much smaller then, and her colors less vibrant, but her methods of exploration were much the same. Using her children as models, Golden staged and photo-

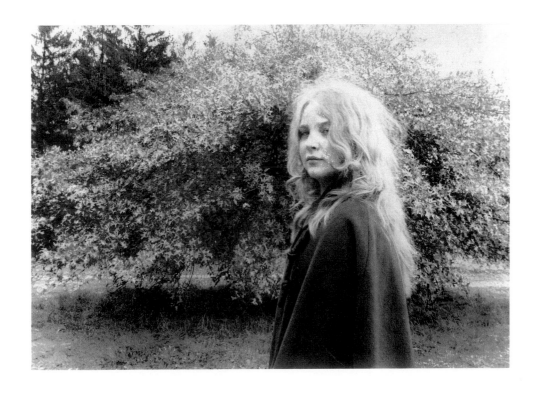

Cycles I, 1972

graphed enigmatic events in the landscape and later enhanced the nostalgic, dreamy quality of her prints by applying artificial color.

Golden's training in art, in fact, began with painting and drawing. She undertook her first projects in these media in 1952, when she received an art scholarship and enrolled at Indiana University to study at an undergraduate level. In Chicago in the early 1960s, married and with two children, she became actively involved with the young artists at the School of the Art Institute of Chicago. She began to attend the Institute full-time in 1968, this time studying photography and printmaking. The photography department was a young, bold and thriving force in the school. Its faculty included Harold Allen, Bonnie Donahue, Joyce Neimanas, Sonia Sheridan and Keith Smith, individuals who encouraged Golden in the development of her vision. Her early work at the School explored a variety of social issues and involved mixed-media etchings and serigraphs that incorporated photographs and words. During this period, Golden also came into contact with Robert Heinecken, whose witty, incisive use of mass-media imagery addressed a number of concerns that were parallel to her own.

In 1973, Golden moved to Northern California to pursue a graduate degree in photography at the University of California at Davis. She worked closely with Harvey Himmelfarb, who was on the photography faculty there, but was equally involved with the painting and sculpture departments, which had a dynamic teaching staff that included Robert Arneson, Roy De Forest, Cornelia Schultz, Wayne Thiebaud and William Wiley. This introduction to Northern California funk art proved to have a significant impact on her imagemaking, encouraging her to exploit the possibilities of humor and color.

Golden used both of these to great effect in the 1975 *Chameleon* series—the first body of work for which she gained wide-spread recognition—creating a poignant social satire on the nature of appearances (plates 1–7). The images in this series were made at a time when Golden felt she was playing many roles. Now divorced, caring for her two children and attending graduate school full-time, Golden was in the position of having to be mother, student, artist, friend and confidante to any number of people on a daily basis. She was acutely aware that her demeanor changed, chameleon-like, according to the individuals she was with, and she used this phenomenon as a starting point for the *Chameleon* series.

In a fashion similar to German photographer August Sander, except with tongue in cheek, Golden set about creating a catalogue of female types. She used only herself as subject and relied on make-up, hairstyle, jewelry, clothing and facial expression to conjure up a long cast of characters that ranged from the girl next door in *Sweet Sue* (plate 2) to a jazz-age sophisticate in *Star Struck* (plate 5). These images are loud, colorful and captivating in their candor and quick humor. They are also executed with a technique as suave in deception as the make-up jobs themselves, leaping freely from illusion to reality through the precise attachment of real objects to the surface of the print. A rhinestone necklace adorns one figure, an actual feather emerges from the tiara of another, glitter applied to the edge of a scarf unexpectedly catches light. All of the images are stitched into plastic so that certain of the applied objects extend beyond their casings, giving the viewer a sensation similar to that of seeing a real face peeking out from behind a painted cut-out at a carnival photo booth. Around the edges of the encased images, further fragments of objects are sewn into the plastic to create a border appropriate to each character. Jewels, glitter, cigarette butts, ashes and bric-a-brac surround the various figures like scraps from dressing-room tables.

This blend of illusion and reality is enhanced by Golden's sophisticated use of hand-applied color. Each of the black and white prints is sumptuously colored with chalk, paint and photo oils, and in some instances these are laid down so heavily that the color appears as rich in texture as the fabric it represents. Hand-written lines of text have also been added to many of the images. In certain of the prints, the text is decipherable as the title of the piece; in others, the words are illegible, but imply a lingering remembrance about the occasion on which the photograph was made. One can't help but peer at these words for clues in the same way one would look at the smudged and blurry notes scribbled on the back of an old family snapshot, but the text Golden has added to her prints gives them a quality of nostalgia and lends credibility to her fictionalized characters.

The motivation for the *Chameleon* series was intensely personal, yet what evolved from these photographs was a lesson so broad and

universal that Golden discovered she could extend her masquerade to the depiction of male characters. The message that we do, indeed, judge a book by its cover, was just as easily (if not more persuasively) conveyed by the male versions of Judith Golden as taxi-cab driver, or detective, or World War II fighter pilot. In these latter images of the *Chameleon* series (plates 4 & 6), a hirsute Golden appears cocky, bright-eyed and chewing on cigars. Real tufts of hair grow from her chest, and a real moustache curls at her lip. So different does each of these characters appear from the next, and from their female counter-parts, that it is difficult to accept that it is Golden's face behind them all, peering through so many different masks.

Golden's exploration of masks and masquerades in the *Chameleon* series soon extended to a broader concept. Not only does every individual wear many masks in daily life, Golden observed; but, conversely, many people are involved in a joint effort to look like the same idealized individuals. Women, in particular, are subject to tremendous pressure from the media to conform to established standards of beauty. The media's promotion of the perfect face and its celebration of youth thus became the subject of Golden's next body of work, also done in 1975. In the *Magazine* series (plate 8), Golden peeks from behind the partially torn covers of fashion magazines, combining her own features with those of the magazine models. Here, Golden represents the American woman as defined by contemporary culture. This is Golden in vogue, with windswept hair, dazzling eyes and a sexy smile, all the while maintaining a fashion-ably young median age.

The first of these images were delicately hand-colored. Flesh tones were subtly applied to the cheeks and pastel hues of blue and green were brushed above the eyes. As the project progressed, a new series, *Magazine Makeovers* (plates 9–12), evolved, in which the colors became brighter and bolder, and Golden began to incorporate bits of text or advertising slogans from the magazine covers. *Summer Changeover, Plays it Hot* and *Body* sit like directives for Golden to follow in her efforts to become a beauty queen.

So successful were these self-portrait fantasy images that those meeting Judith Golden for the first time would be greatly surprised. After seeing her in her photographs in so many disguises, as Sweet Sue and Motorcycle Man and the perfect *Vogue* model, one might expect her to *be* those characters. One might *expect* windswept hair and perfect make-up on a tall, svelte figure. Instead, one would be startled to come face-to-face with a petite woman, not more than five feet tall, wearing a printed skirt, cowboy boots and no make-up at all. For anyone who has studied Golden's prints, meeting her is a delight. The experience serves as the best moral to the story of her pictures—appearances are rarely as revealing as they seem.

Playing the roles of so many different characters has demanded from Golden a fair amount of theatrical hamming. To mimic a model's appearance well enough to blend into the magazine cover, Golden has had to act out the model's gestures in addition to copying the make-up and hairstyle of each. In her *People Magazine* series (plate 13), which began in 1976 as an extension of the more general *Magazine* photographs, she had to rely particularly heavily on play-acting as she substituted her face for that of various celebrities on the cover of the popular weekly. Golden's *People* covers succeed on one level because of their outrageous conceit—that Golden should expect to share stardom with our favorite pop figures is something akin to Andy Warhol's prophecy that television would make everyone famous for fifteen minutes. On another level, however, the images go beyond humor and conceit to inspire a serious yet satirical investi-gation of contemporary values regarding fame, wealth and the right to privacy. Golden became interested in the phenomenon that we, as Americans, feel entitled to an inside view of our celebrities' per-sonal triumphs and traumas. Her *People* covers make transparent our lust for the public ownership of private lives and our collective desire to buy into the myth of Hollywood success.

For anyone who has lived in Los Angeles, as Golden did from 1975 to 1980 while teaching at the University of California, the movie industry becomes a curious and inevitable part of daily life. Even for individuals not professionally associated with Hollywood, the film business is so pervasive that it seems to loom behind the city like a backdrop against which the rest of urban life occurs. The stretch-limos on Sunset Boulevard, the opulent sprawl of Beverly Hills and the steady stream of billboards that line the city streets are simply part of the L. A. vocabulary. For Golden, who was keenly alert to the vagaries of this environment, Hollywood memorabilia served as

perfect subject matter for her imagemaking. Where better to explore masks and masquerading than Los Angeles?

In the *Ode to Hollywood* series (plate 14–17), which was done between 1976 and 1978, Golden continued to use herself as a model, as she had in all of her earlier self-portrait fantasies. For these new photographs, Golden collected antiquated lobby cards and photographed herself from the same angle and under the same lighting, mimicking the heroine's expression. After covering the heroine's head with her own image, she rephotographed the lobby cards and printed them on a scale of up to four by five feet. As the series progressed, Golden began to search selectively for those lobby cards that depicted the heroine in a position of strength or power, but these became increasingly difficult to find. She discovered that, even in films ostensibly about tough women, the stills selected for publicity purposes nevertheless managed to portray the heroine in a vulnerable or subordinate position. *Ode to Hollywood* ultimately took shape as a terse criticism of the self-aggrandizing, macho image of the film industry in the 1950s and 1960s.

While the *Ode to Hollywood* series matches Golden's earlier work in its wit and unequivocal social commentary, it surpasses all of the previous imagery in its virtuosic technique. These pictures are big—unusually so for 1978—and heavily painted. The objects that are attached to the surface of the print not only create a *trompe l'oeil* effect, but also set up a new kind of visual screen that exaggerates illusory space. Roses, feathers and jewelry still sit where they should, accurately placed on top of their photographed counterparts, but other objects float in patterned rows in front of the image. In *These Thousand Hills* (plate 16), small pink bows, like those on a quilted blanket, form a grid on the surface of the print. In other images, rows of toy soldiers, airplane propellers or red fabric hearts playfully compete for the viewer's attention and make the picture behind seem to recede into a deeper space.

These prints represented a departure for Golden in terms of their sophisticated technique, yet they also challenged the boundaries of traditional photography in their derivation of subject matter. Golden's photographic contribution to the *Ode to Hollywood* series is minimal. Within the large scale of the movie poster, her face marks

out a very small area; for the most part she is giving back to the viewing audience photographs that already exist for the public. Today, this practice of recycling media imagery is generally accepted as a primary working methodology of Post-Modern photography, but at the time Golden made the Hollywood images, in the mid-to late-1970s, it was an unusual and forward-looking concept.

Golden has not been properly credited for this early role in the formation of the Post-Modern ideology, which has been celebrated more recently in the work of such photographers as Cindy Sherman, Barbara Kruger and Richard Prince. While Golden's recent work has not adhered to the basic tenets of Post-Modern thought—which, in essence, contend that the only new images or ideas are those regenerated from the existing mass media domains of advertising and political imagery—her early use of media photographs paralleled, and indeed preceded that of artists working in this mode today.

Golden's visual investigation of the ways in which women are portrayed in the media led to a desire to look more closely at the possibility of photographing the women who were her friends and colleagues. Just as living in Hollywood exerted an influence on Golden's imagemaking, two trips to Berlin, in 1979 and 1980, inspired new experimentation in the use of color and encouraged her to return to the use of models other than herself. In her portraits, she began to borrow formal elements from the original work of German artists she had viewed in Berlin. Seeing works by painters of the German *Neue Sachlichkeit* (New Objectivity) movement first-hand offered her a new understanding of pictorial devices that emphasize psychological tension by placing characters in close, distorted environments. The painted portraits of Christian Schad, in particular, create a sense of psychological crowding by depicting a figure squeezed tightly in the frame, with the hands or limbs of other figures pushing in against the central form.

Other aspects of German creative activity influenced Golden's imagemaking as well. She was particularly impressed by the intensely expressionistic nature of much of the country's contemporary artwork. In addition, the history of the cabarets of the Weimar period, and the hard-edged, sardonic nature with which German painters of the 1920s and 1930s portrayed the decadence of their

culture offered Golden a framework for the presentation of her highly stylized *Portraits of Women* series (plates 18–19). These images depict women in rigid, formal poses in an enclosed studio environment, surrounded by satin drapery of luscious, almost lurid colors. Each woman confronts the viewer with a stare that vacillates between confidence and belligerence. None are passive, nor are they vulnerable. Instead, each wears a mask of practiced control that differs dramatically from the warm, amenable features of Golden's earlier magazine cover girls.

The photographs in this *Portraits of Women* series (1981) introduce the element of interpersonal relationships to Golden's work. They explore the relationship between subject and photographer and, by implied extension, between the subject and any viewer confronting her. In the subsequent *Relationships* series (1982), Golden explores the tension and ambiguity that result from two or more individuals coming together in a confined environment or situation. The nature of relationships, and particularly of sexual relationships, was also the subject of an earlier, humorous series, *The Forbidden Fantasies* (1979), in which she superimposed her own face and the faces of various male art-world notables over those of characters in a group of erotic prints from fifteenth-century China.

The prints in the *Portraits of Women* series mark Golden's first complete body of images executed entirely in photographic color. In addition, except for small touches of dye that she applied to the print by hand to enhance the red of lips or fingernails, the photographs in this series are unmanipulated. In the process of making the portraits, Golden discovered that the range of hues possible in contemporary color films and papers suited the temperament of the message she wished to communicate and that the prints required little or no alteration to achieve the statement she wished to present.

During the past few years, Golden has worked consistently with color photographic materials. In 1983 she was given the opportunity to work with the Polaroid 20″ × 24″ camera, and it was using these large-scale Polaroid materials that she fully developed her *Persona* series (plates 24–27), a project begun a year earlier in Arizona. The Polaroid film yielded an intensity of color unattainable in other photographic materials, but more pertinent to Golden, the camera

itself presented a unique set of working parameters. Because of its tremendous size and weight, the camera is confined to a studio, and artists using it must construct their images in front of the lens. The system requires a certain economy of means, which allowed Golden to develop her growing interest in pared-down visual symbols. While making the portraits of women, she discovered that the isolation of the studio environment intensified the evocative, emotional charge of her models. She was becoming less interested in the mask as a cosmetic cover and more interested in its potential as a symbol of psychic transformation.

Rather than simply concealing an inner being, Golden felt a mask might also be a vehicle through which an individual could experience other things. She set about creating a series of portraits called *The Elements* (plates 20–23) that turned her models into characters drawn from mythology. In each of four photographs she created archetypal characters representing the forces of earth, wind, fire and water. The simple, yet poignant props she used focused the viewer's attention on the model's painted face. Painted seamless paper backdrops, rich theatrical lighting and strange cut-out shapes surrounding the figure all blend in with the masked face, so that the environment itself seems born from the core of each mythical character. For the first time in Golden's work, the figure and the environment become entirely interdependent. Also for the first time, specific references to contemporary culture are abandoned. Whereas all of Golden's previous photographs reflect contemporary American culture through a mirroring of its media imagery, the characters in the *Elements* series seem to exist outside of time, and within a separate value system. Golden's experimental use of artificial light in these Polaroid images enhances their timeless, fantastic quality. Eerie midnight blues and fiery oranges suggest characters reminiscent of the faeries in *A Midsummer Night's Dream* or the members of the damned in Dante's *Inferno*.

Golden has continued to expand upon this cast of mythical characters at her home in Arizona, and the physical environment of the Southwest has become a crucial element in her most recent work in the *Cycles* series (plates 28–32). It is not the grand vistas of the terrain that concern her, however, but the harsh, dry groundcover and the tenacious vegetation that remind one of the arduous struggle for

survival. The individual subject's relationship with the earth's forces has become the central focus of her work; the mask continues to be the primary means by which this relationship is established. Golden's characters are still chameleons, camouflaging themselves in their surroundings; but the environment now is the earth itself, rather than a media-dominated society.

As with all of her earlier series, Golden's current photographs have become richer and more complex in their technique as they have progressed. In the first *Persona* images, Golden added only a small amount of color, and that by drawing with markers on the transparencies before making otherwise unmanipulated prints. The backgrounds, too, were simple, flat surfaces constructed in a studio. As the series evolved into the *Cycles* series, Golden returned to the extensive construction of her images, and to the elaborate manipulation of both the print and the enclosing frame with hand-coloring, painting and assemblage. Finding these techniques so effective in communicating a psychic transformation, Golden recently reworked an earlier series of images, *The Elements*, to incorporate drawing, collage and mixed-media frames. The *Cycles* series is differentiated from *Persona* by this more exaggerated technique, and it is appropriate that this series, which shares its title with that of Golden's first body of work made more than a decade earlier, returns to ideas and techniques that concerned her at the start of her career. Of course, fifteen years of introspection and diligent labor have resulted in a clarity of expression and a quality of craftsmanship that were lacking in the first photographs. Now, too, it is Golden's grandchildren who take the place of her children as the young models in her photographs. But it is the issue of growth, of the cycles of life and death and the projection of one's self-image that remain the key philosophical components of her photography.

Golden has used herself as a model to explore the significance of masks and masquerading in our culture for many years, but even though she now works with models other than herself, her image-making process continues to be one of self-exploration. Masks continue to be the vehicle by which she can experience a new understanding of time and self, and it is through the depiction of the masks that she communicates this understanding to her audience. In the end, Golden's cast of fictionalized characters shares with its viewers the insights that Golden herself has made as a contemporary American woman living first in an urban, media-saturated environment and second in the relative isolation of the desert.

Judith Golden's contribution to photography continues to be multi-faceted. Since the start of her career, she has consistently been at the forefront of critical thinking in the medium. She was an early practitioner of hand-coloring and assemblage. She was a pioneer of image appropriation and the "big picture." And, as long as a decade ago, she was a champion of feminist issues regarding the portrayal of women in the mass media. All of these accomplishments have been made in a photographic style that is Golden's own—a style that combines humor, wit and clarity with a flawless handling of materials. At present, Golden is extending the technical boundaries of photography once again with her mixed-media *Cycles* imagery, and is making new and important contributions to our understanding of the human psyche. Whatever comes next, one can rest assured that it will be in the same spirit of conviction and lively experimentation that makes Judith Golden one of the most exciting photographers working today.

Claire V. C. Peeps is executive director of Astro Artz, a non-profit organization in Los Angeles which publishes High Performance *magazine and sponsors a variety of activities in new theater, music, video, film, dance and visual arts. Prior to moving to Los Angeles, from 1982 to 1985, she served on the staff of The Friends of Photography. With Stephen Brigidi, she contributed the introduction to* Mario Giacomelli *(Untitled 32, 1983). She received her M.A. degree in art from the University of New Mexico in 1982.*

The following interview was conducted on July 27, 1987, at the Tucson Museum of Art, which was then showing a retrospective exhibition of Golden's photographs.

Who is Judith Golden?

That's a very difficult question. I think most of us spend a lifetime searching for who we really are. I guess I'm no exception. I think we define ourselves by outward labels or roles such as artist, mother or lover. My earlier work was about that, but that still is only the surface. The image is visual, and it doesn't indicate what's underneath. As my work has progressed I have become more metaphysically oriented and more deeply interested in who we are, how we fit into the universe, how our time period fits into eternal time. I hope the work reflects some of these ideas about the human connection with the earth.

Among the reasons for choosing to be an artist, what was most important to you?

Well, first of all, I'm not sure I did choose. As a child I always thought I would become an artist. When I was young I loved to draw, and I did a lot of reading as well. I think I had a fantasy world that was more relevant to me than my real life.

What kinds of things were you reading?

All sorts of things. This was when I was in grade school. I would go to the library and check out as many books as they would allow. Most were stories about people; more fiction than history, but I wanted to know about different countries. I was always fascinated with how people lived at many different levels and in other times.

Does any particular book stand out in your memory?

By the time I was in high school, I was reading a lot of Russian work, and I remember I was fascinated with Tolstoy. I would sit up all night and read. I always got very emotionally involved with what I was reading. I was *in* those situations. I remember my parents coming downstairs on several occasions at three oclock in the morning and saying, "Why are you up, and why are you crying?" And I'd say, "This is very sad, these terrible things are happening." And they'd say, "Well, put that book away." They just didn't share the kind of adventure I found in reading.

Do you still read the same way?

I do quite a bit of reading, but my reading material now is a little bit different. Of late I have been reading a lot of things connected with Carl Jung and Joseph Campbell's books on mythology.

Why did you choose photography as your medium?

That's another thing that just happened. I went back to the Art Institute of Chicago to finish my BFA degree when my children were about eight and ten. I had been doing a lot of painting and printmaking. In fact, before I went back to school full-time, I had gone to the Art Institute to take Saturday classes in etching and became really fascinated with its possibilities. When I went back to school, it was as a printmaking major. I was primarily interested in etching, but I also did some lithography and silkscreen. I became interested in using photographic images as part of my printmaking. Keith Smith was at the Art Insitute at that point. I still have a great deal of admiration for him, the way he so easily moves from one medium to another using drawing and printmaking. I think his books are wonderful.

You have said that you identify with Julia Margaret Cameron as an artist. What do you mean?

I've been very attracted to the work of Cameron because of the incredible power in her photographs. She captures the essence and energy of the person she photographs. I feel a strong contact, a connection, when I look at her work.

Do you think that's for reasons of style, or because of the allegorical aspect of her work, and perhaps of your's too?

Both. Our portraits are quite direct. Many of them are of the head or upper torso. There is also a somewhat romantic quality in some of my later work that's also in hers. She often photographed outside. There's one photograph I particularly like of Alice Liddell against foliage, which I just came across recently. I thought again of the relationship of Cameron to some of my recent portraits in which I've placed a figure against a similar background.

But it is an issue of empathy, not imitation, is it not?

Yes; it's not direct reference, in that I don't look at what she's done and then make a similar photograph. I'm not trying to reference

a known work of art like many photographers have done lately. Joel-Peter Witkin comes to mind, for instance. He is consciously taking images from various art historical periods, rethinking them and adding other levels to them in his own pictures. I think that is a totally legitimate and fascinating way to work, but I'm not really working that way. When I discover artists from the past who have an aliveness for me, such as Cameron, or the surrealist Mexican painter Frida Kahlo, I think of them as friends. They are with me when I work.

You have expressed interest in the psychological studies and philosophy of Carl Jung. Is a particular aspect of his thinking manifested in your work?

I'm very interested in his studies on the the anima and animus, the masculine and feminine within each of us. In my later work, starting with the *Persona* series in late 1982 up until the present, the balancing of the masculine and feminine element is something that I have concentrated on. I photograph children because of their androgynous nature. I'm also very interested in pre-Christian cultures, in how their goddess figures still have a great deal of influence. This is important to me. Not too long ago I came to the conclusion that I really do want to honor the feminine, the nurturing, the mystical; those aspects that we're not very aware of as a culture right now. A lot of my thinking has come out of reading about Jung's archetypes and interpretations of mythology. What those mythological characters represent is still relevant to us because they remain a part of us.

In what way has your background in drawing and painting influenced your current work?

A great deal. From the time I started photography, I first made black and white prints and then went on to paint and collage them. My work has always been very involved with color. For a while in the early 1980s, when I switched to using color photography, I challenged myself to make only straight color photographs. I couldn't resist using transparent dyes to intensify certain colors, but I didn't paint or blot out photographic information on the surface of the print. That particular work I feel less involved with personally, though, because of my love of playing with the surface. The hands-on work—the painting and collage—is something I enjoy doing much more than printing. I love the alchemy of watching the print come up in the

darkroom, but I don't like being in the dark and printing one print after the other. This means that much of my work is one of a kind. The idea of doing a lengthy edition has never appealed to me because I am interested in the image, and once I have the image I want to go on to another.

Would you say that your immediate environment is always an influence on your work? Examples I have in mind are the Ode to Hollywood *series that was made in Los Angeles and the* Elements *series from Tucson.*

I'm very influenced by my surroundings. When I first moved to Tucson, I was still working on the *Portraits of Women* series, which was strongly influenced by two trips to Berlin. I felt totally uncentered because I didn't feel I had completed the series, but here I was in a new environment that was so entirely foreign. I had huge expanses of sky around me, and desert, and there was a beckoning from nature. The first year I was here I was struggling against that. I still found myself working in the studio, closing my eyes to what was around me, but it didn't feel right. I finally realized that whether part of my mind felt that the *Portraits of Women* series was complete or not didn't matter, because it really was finished in another way.

Your work has been called "myths and masquerades." Does this include your Portraits of Women *series too?*

I think so. Much of my work has dealt with masking and with facades. The more recent work deals with a very obviously painted mask that blends the figure with the environment. Even in the earlier work, the *Chameleon* series, the mask reflects the roles we accept in life, which are another kind of facade. The portraits of women are not intended to represent individuals, though. My work always has to do with more of a collective idea. It's the whole group, rather than one person, that is of concern. I wanted the women I photographed, most of whom were my friends, to represent the strength of women, but also to indicate a level of fantasy. Women do like to dress up; little girls like to dress up. This polarity of strength and softness is often hard for contemporary men to deal with, and hard for women, too, since roles are switching drastically and very quickly. Now, women are taking on many masculine roles, but don't want to give up the feminine. I think we need to value both of these parts and use them when it is appropriate. I wanted to show both those

polarities in the *Women* series. I'm not sure if that's clear to the viewer, but it's what was in my mind.

The majority of your work uses either yourself or other women as subjects. Would you elaborate on your comment that this is a way of "honoring the feminine?"
In all of us there's a masculine and a feminine side. I think that we feel centered when those sides are balanced within ourselves. That doesn't mean that we don't act out of a totally masculine side when it's appropriate, or out of a totally feminine side when that's appropriate. I'm not saying that either one is right or wrong. But when it's off balance, when one part has all of the power, I think there are problems. The world has been very off balance for a long, long time. The feminine aspect, the earth aspect, the nurturing aspect, the intuitive aspect has not been balancing patriarchal power and aggressiveness. We're at the position now, because of modern technology, that we could destroy everything we have. Personally, I feel very sensitive to that, and I need to say something about it in my work. The earlier work was really about defining a role: Where do I fit? Where do we fit as contemporary women in the midst of all these changing roles for men and women? That has evolved to a more metaphysical look, to a much more universal question: Where do we fit into this whole time continuum? Where do we fit universally? My recent images suggest ancient cultures, when women were honored for the mystical and powerful abilities they had. I'm looking at what happened to this power, and how we can reclaim it, how we can create a balance that will allow us to coexist both individually and on a global level. I make images that reflect the feminine, the intuitive, the mysterious. I'm after the connection with earth rhythms, cycles, changing seasons, birth moving toward death. Those rhythms are a part of what I am talking about in the work and thinking about when I do it. I've been reading a lot of fairy tales, a lot of mythology. And I've been looking at the archetypal female figures; at how we all relate to them and how important they still are.

Self-portraiture has a variety of precedents in the art world. How would you describe your own self-portraits from the 1970s?
The early work I would describe as psychological and political, in that I really was trying to make a point. I think the later work becomes quite allegorical. The motivation for doing the early work came from

feeling that, as an individual in this particular time period, I was doing a balancing act between all these different roles. I also felt that it was important to expose these ideas to other women, particularly young women, as a way of creating an awareness of where we were. The reason I used myself is because I was a very available model. Initially, I wanted to see how I fit into those roles; but, when I first started, it wasn't with any long-term plan to do years of self-portraits. As I started doing them, they became more stereotyped and developed into a more exaggerated expression than I had originally intended. That happened as a part of the experience of doing the pictures. The idea of doing men came out of having all those stereotypes of women. So what about stereotypes of men? Again, it wasn't anything I had planned, but came from the experience of doing the work. In the movie posters I wanted to show how women were depicted in film and saw the rather passive way that so many of them were portrayed. The basic message was: Just take a look at this. See how we're being influenced. Don't let that influence catch you unaware. I guess the more recent work has some of the same messages. That is: Look at our connections with the earth. Don't lose track of that intuitive, mysterious, inner part of who we all are.

You have a series titled "Chameleon." Does your chameleon change in order to camouflage itself, or for some other reason?
Camouflage is a good word, because when we fall into these identifiable roles, it does create a camouflage. You're protected as long as you're behind it. If you perfect the role and something comes along that doesn't quite fit into that script, then what do you do? You're trapped. If we allow ourselves to be caught in a role, it becomes a camouflage of who we really are. We're only showing one part of ourselves, and I think everyone is multifaceted. I'm suspicious if anyone is too consistent. Role playing is a camouflage for all those other levels that are a part of the human experience.

Do you regard your work as "experimental"?
I don't think the work I've done to date is very experimental. In the mid-1970s, when I started doing the big movie posters, which had a lot of collage, very few photographers were working large. Color photography was just starting to emerge in the museum world. Not many artists were doing a lot of painting, working so freely on the

photographic surface. I don't know if I would call that experimental, because for me it came out of a blending of my own background. Now there is much more of that kind of combining of media.

Would you describe your style of photography in terms of the reality versus illusion question?
I think a photograph, whether it's set up or something you find in the world, has a great deal of strength, because we as viewers accept it as reality. Even if it appears to be a very strange, magical phenomenon, we somehow accept it as real because it's in a photograph; that is the power of the medium. I think there's something special about the way eyes look right at you in many photographs. There's a human connection, and that acceptance of reality is important in my work. On the other hand, I'm fascinated with the illusion of photography. A photograph is of something that may or may not have been real. When we talk about a photograph, we talk about the reality of its subject, rather than the illusion of it. That's something I thought about a lot in my early work, when I would collage an actual object on top of the photograph of that same object. Which is the illusion and which is the reality? The object has three dimensions, the photograph only has two. But the photograph depicts detail and three dimensional space so incredibly well that we think

we are looking into that space. The whole cycle of illusion and reality, how they meld and separate, is something that has always fascinated me.

Had the fates not delivered you into the hands of the art world, what else might you have become?
A psychologist, I suspect. Psychology is something that has always interested me, and I think it reflects in my work.

How would you like to be remembered by the art world?
What pleases me most is when an audience experiences a connection with my photographs. I would hope that in the future people will relate to my portraits and sense a strong connection, an aliveness, an energy of the human essence.

James L. Enyeart is director of the Center for Creative Photography at the University of Arizona in Tucson. He is a recipient of the Guggenheim Fellowship and the National Endowment for the Arts Fellowship for writing. He has also received NEA grants for photography. Prior to assuming his position at the Center, Enyeart served as executive director of The Friends of Photography.

Chameleon *Series, 1975*
Gelatin silver prints, chalk,
oil pastels, collage elements,
stitched in vinyl; 14" × 11",
vinyl 20" × 16"

Magazine *Series, 1975*
Gelatin silver prints, oil
paint; 14" × 11"

Magazine Makeover *Series,*
1976
Gelatin silver prints, oil
paint, glitter; 14" × 11"

People Magazine *Series,*
1976–1978
Gelatin silver prints, oil
paint; 14" × 11"

Ode to Hollywood *Series,*
1977–1978
Gelatin silver prints, paint,
chalk, glitter, collage elements;
30" × 40" or 40" × 60"

Portraits of Women *Series,*
1980–1981
Cibachrome prints, dye;
40" × 30"

Elements *Series, 1984–1986*
Polaroid prints, mixed media;
30" × 26"

Persona *Series, 1982–1985*
Persona XV—*Cibachrome*
print, mixed media; 30" × 26"
Persona X, XI *and* XIII—
Polaroid prints, mixed media;
30" × 26"

Cycles *Series, 1984–1985*
Cibachrome prints, mixed
media; 30" × 26" or 26" × 30"

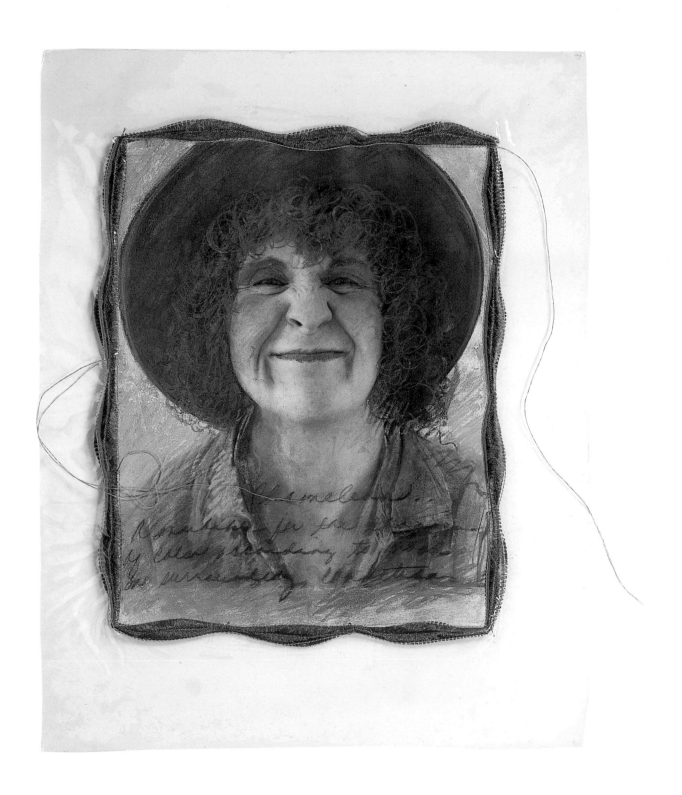

Chameleon

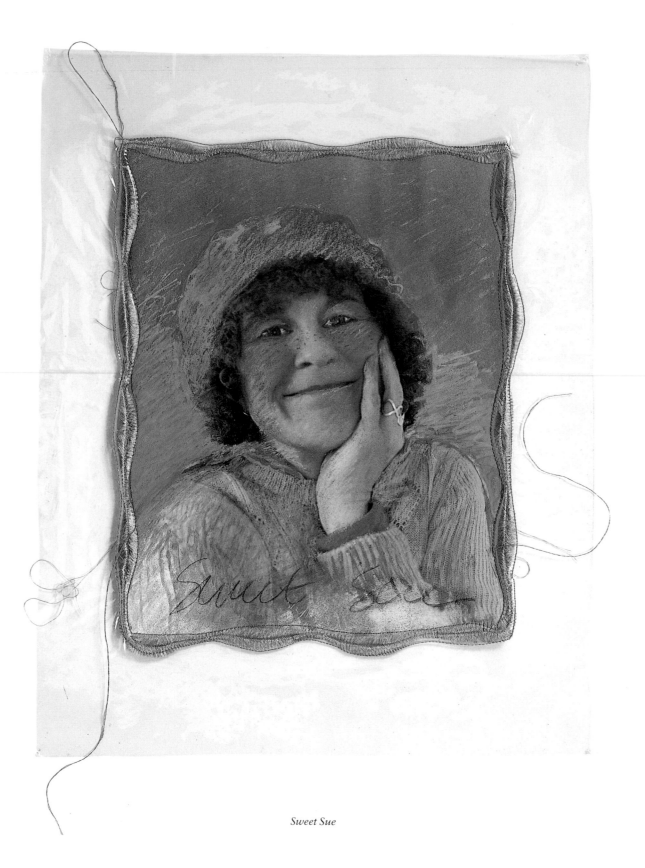

Sweet Sue

PLATE

2

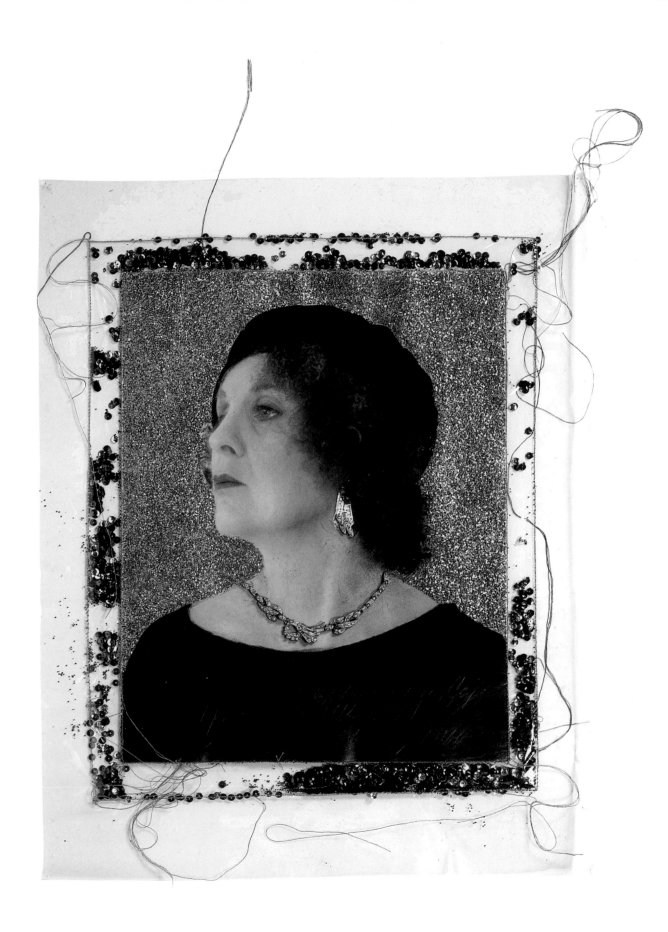

New Year's Eve at the Waldorf-Astoria with Truman Capote

PLATE

3

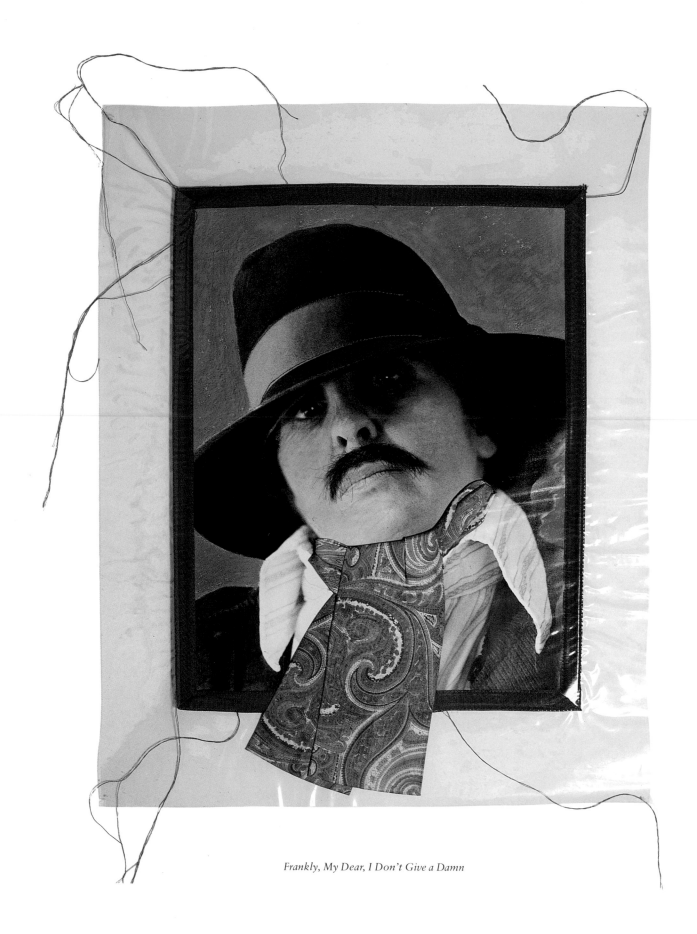

Frankly, My Dear, I Don't Give a Damn

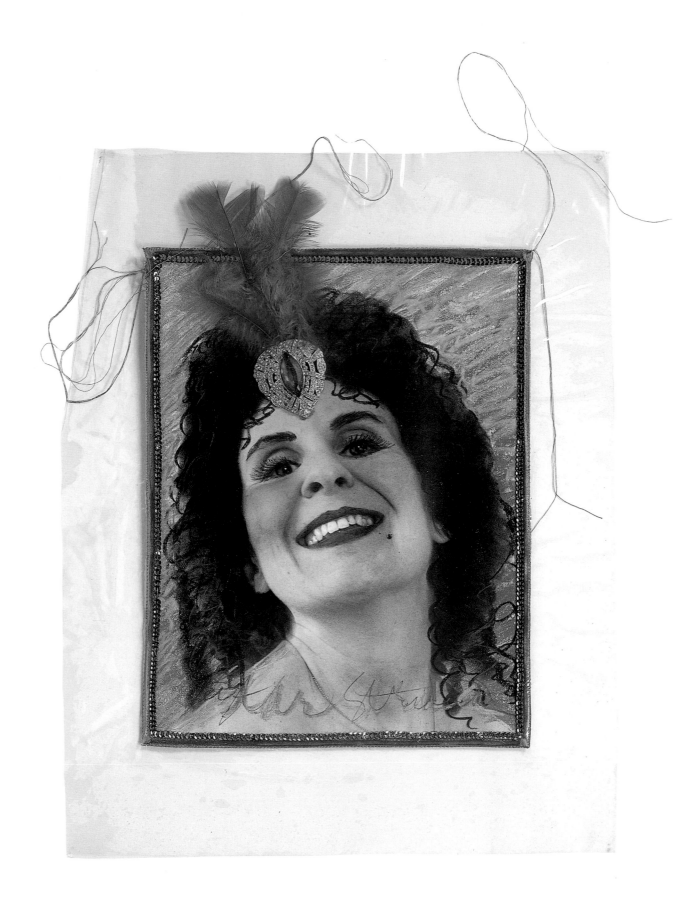

Star Struck

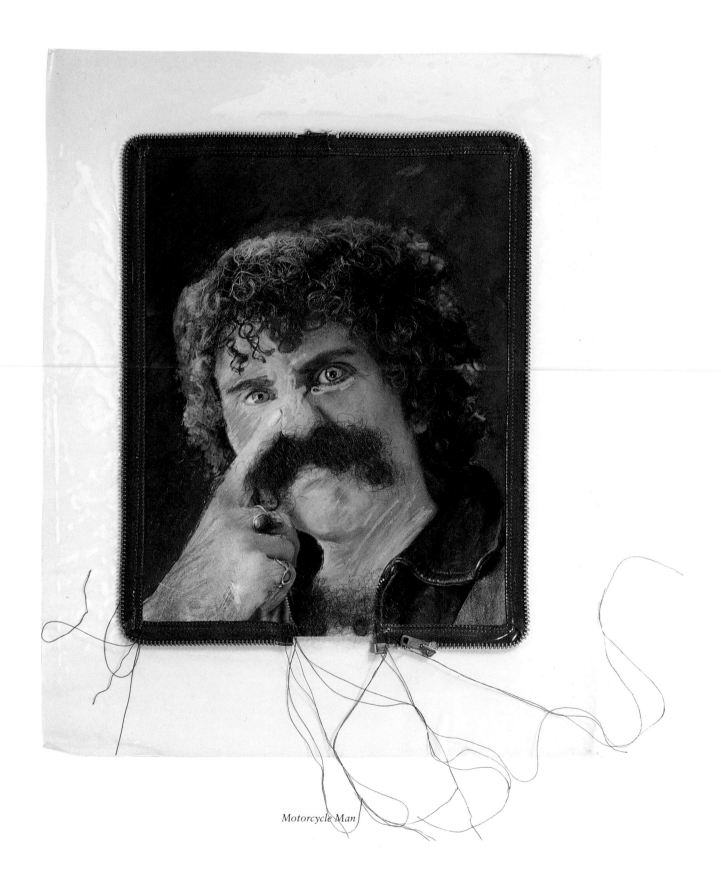

Motorcycle Man

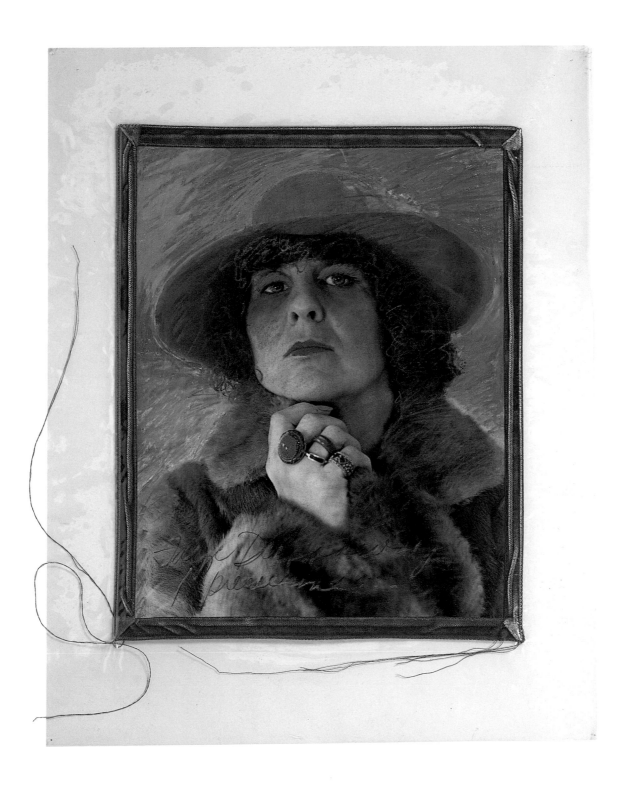

Faye Dunaway, Warm

PLATE

7

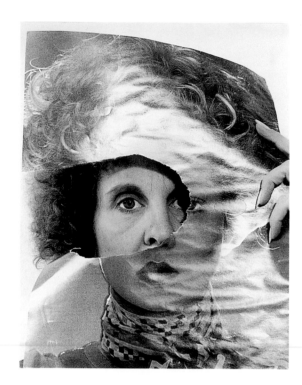 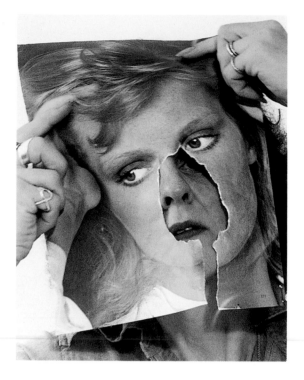

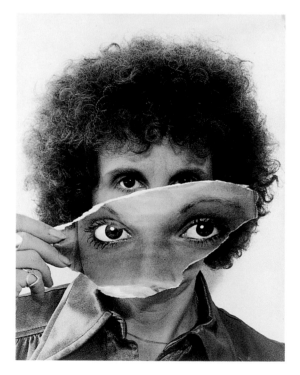 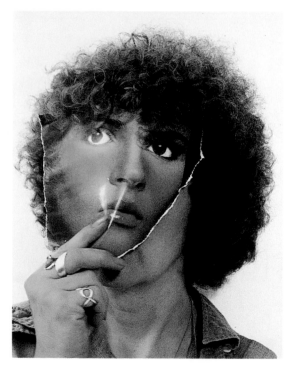

From the Magazine series

PLATE

8

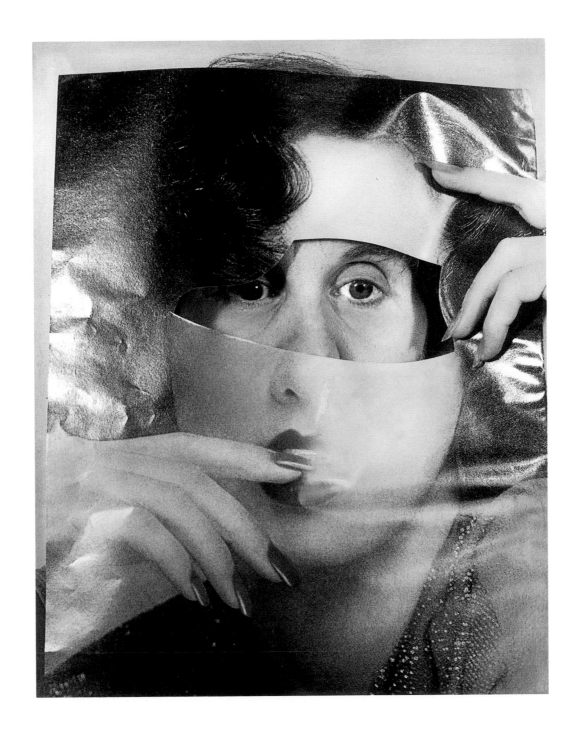

Rhinestones

PLATE

9

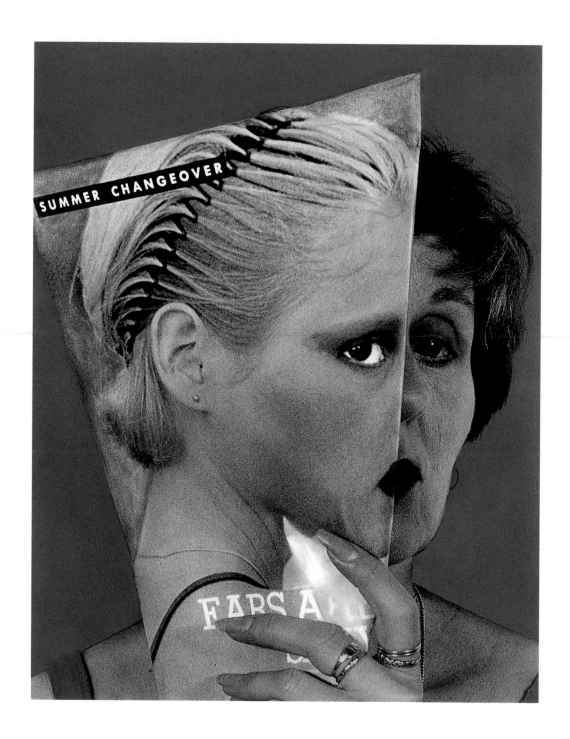

Summer Changeover

PLATE

10

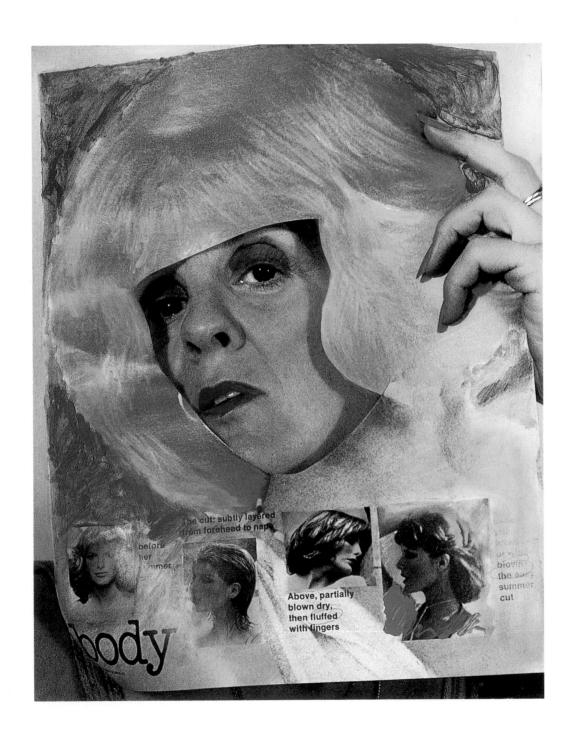

Body

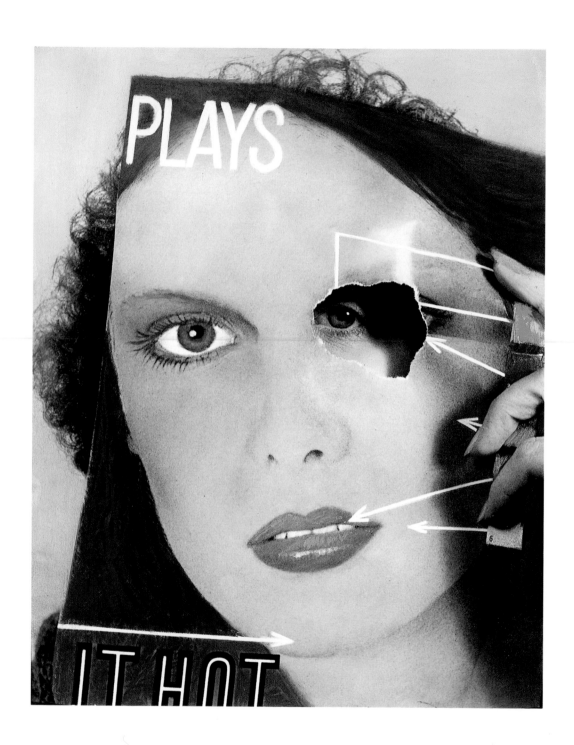

Plays it Hot

PLATE

12

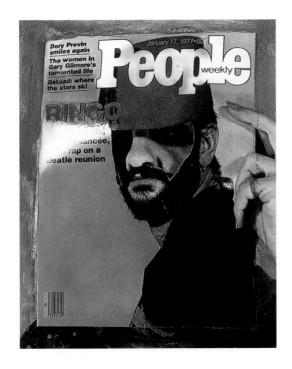

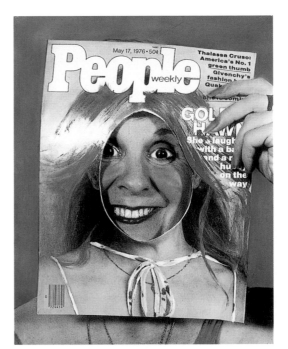

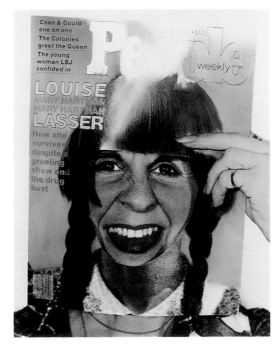

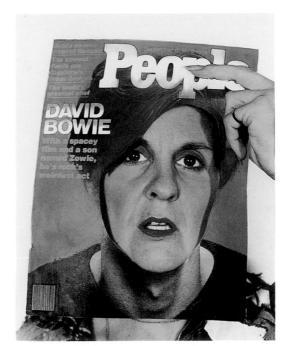

Ringo

Goldie Hawn

Mary Hartman

David Bowie

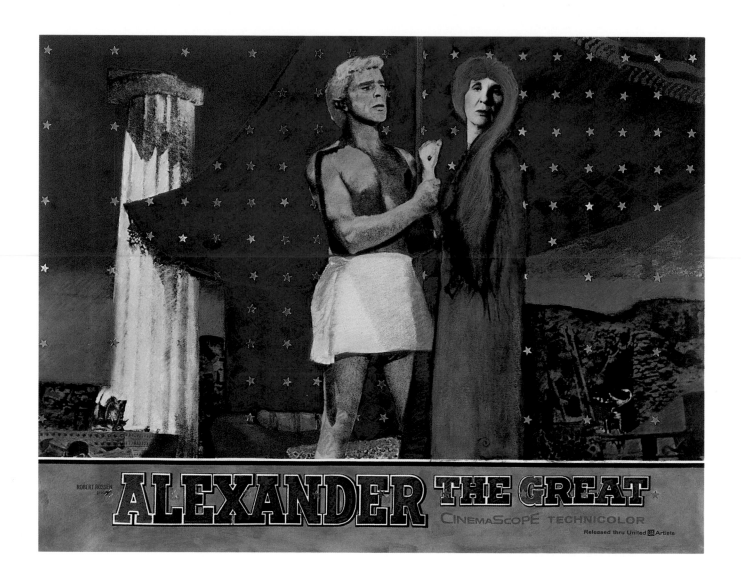

Alexander the Great

PLATE

14

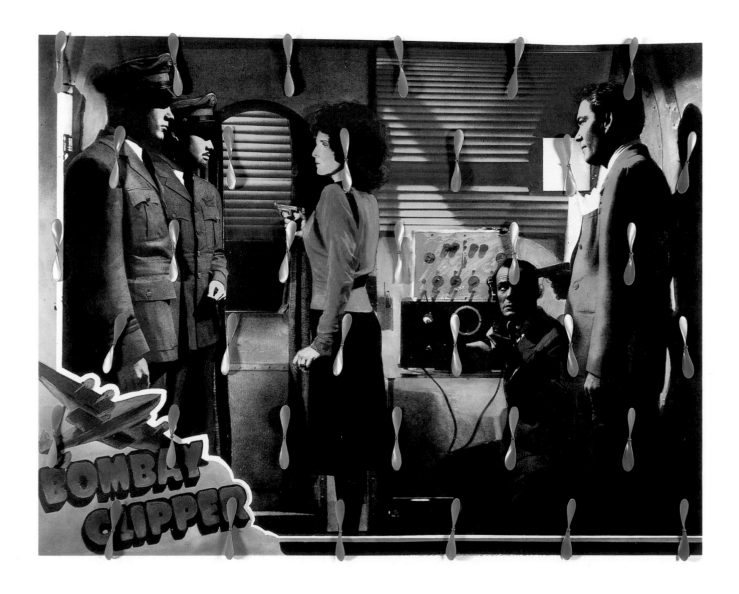

Bombay Clipper

PLATE

15

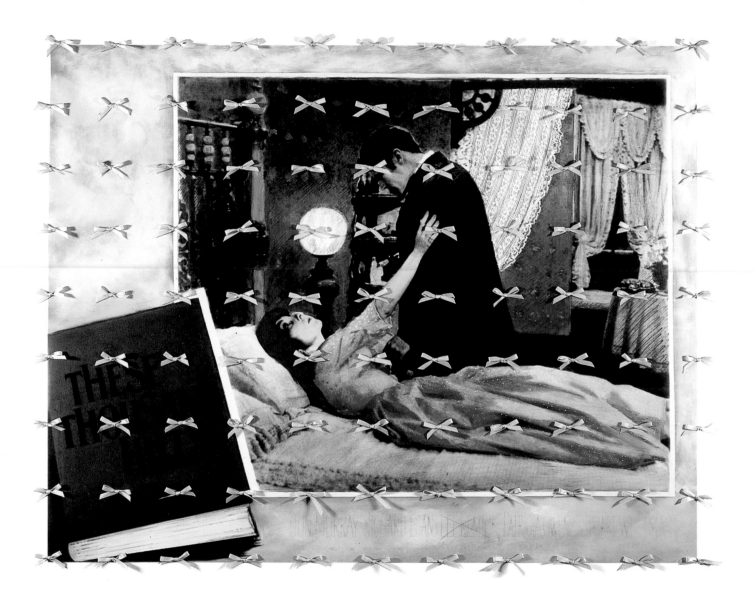

These Thousand Hills

PLATE

16

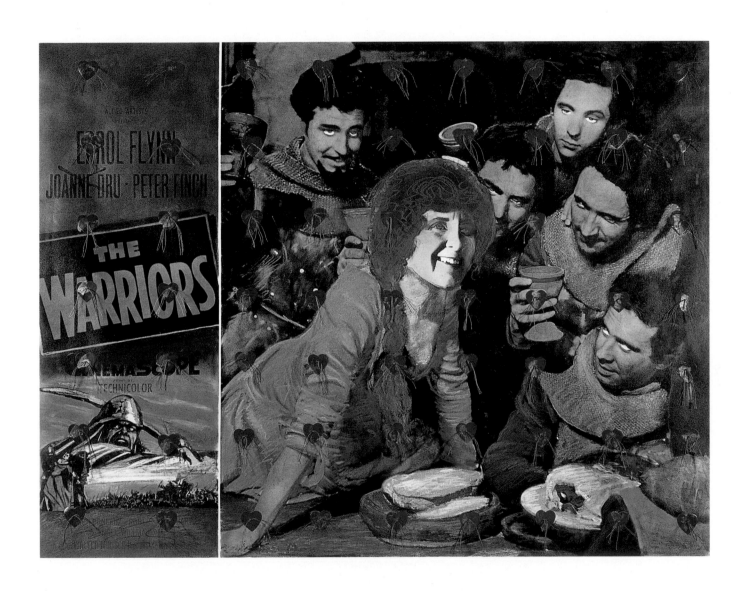

The Warriors

PLATE

17

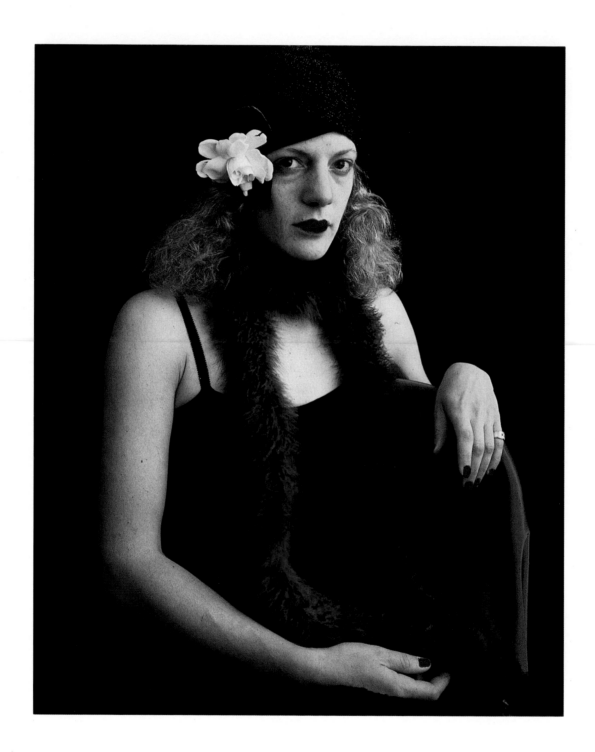

Debra

PLATE

18

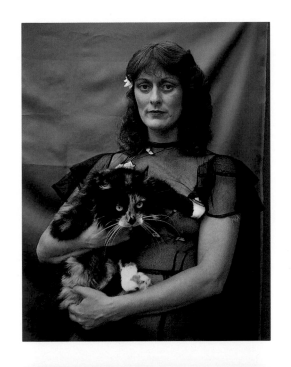

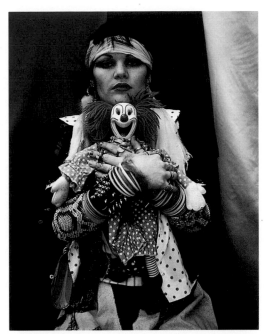

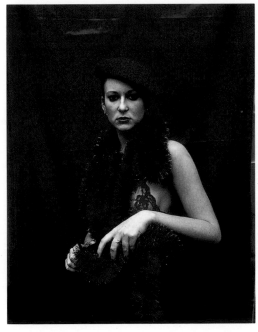

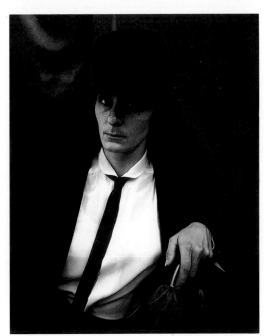

Karen

Naomi

Robin

Dorothy

PLATE

19

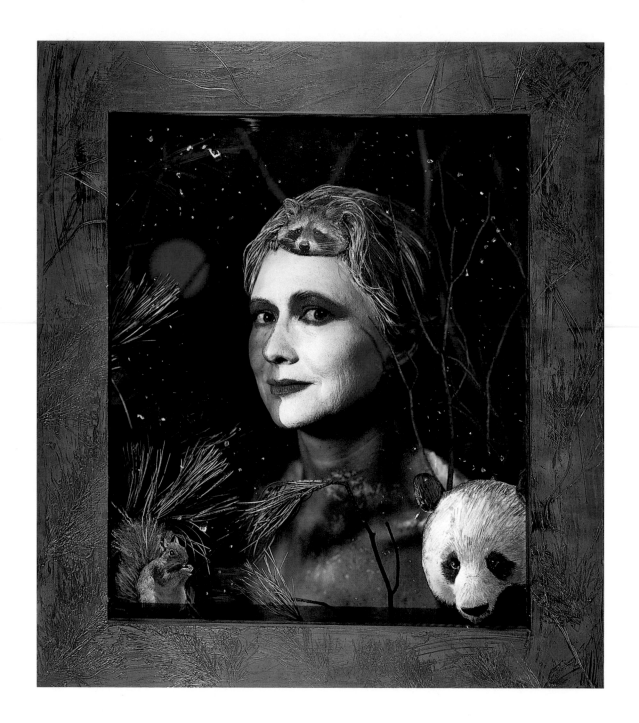

Earth

PLATE

20

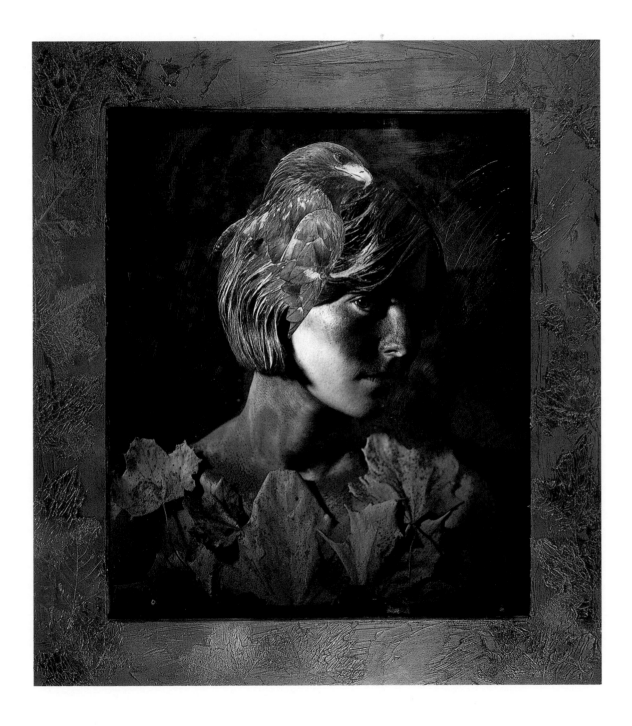

Air

PLATE

21

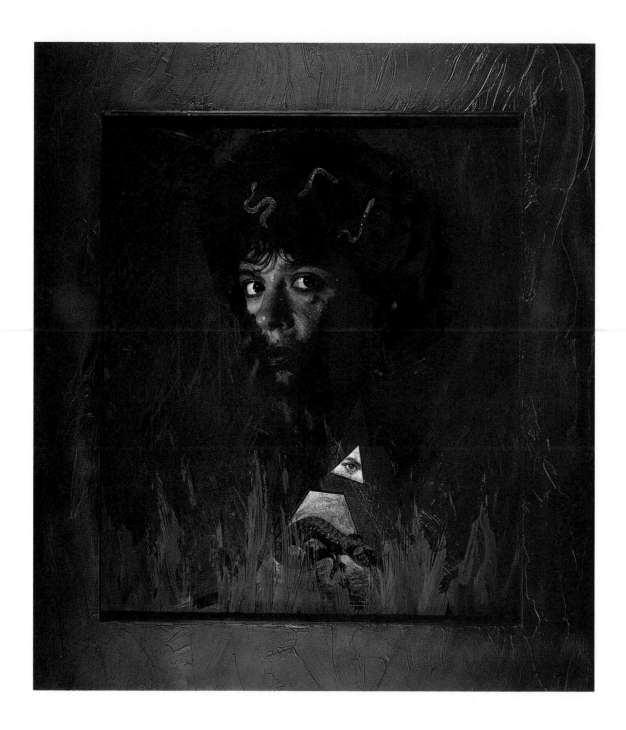

Fire

PLATE

22

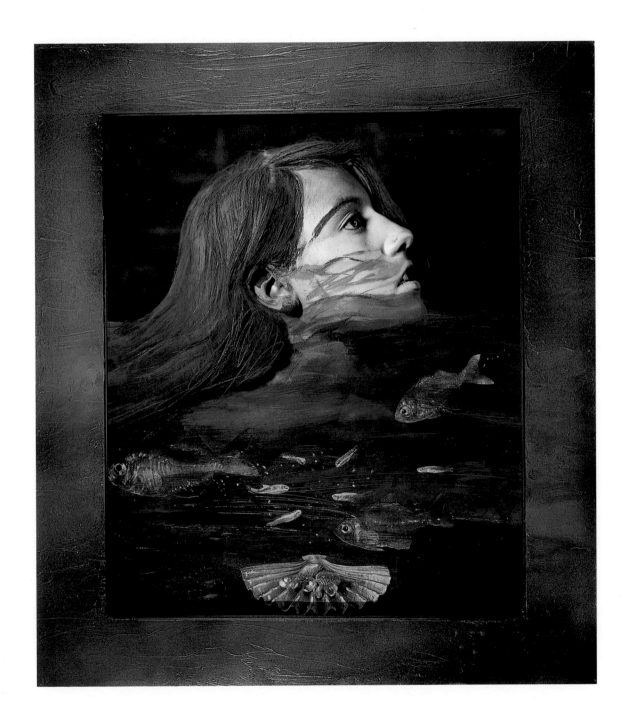

Water

PLATE

23

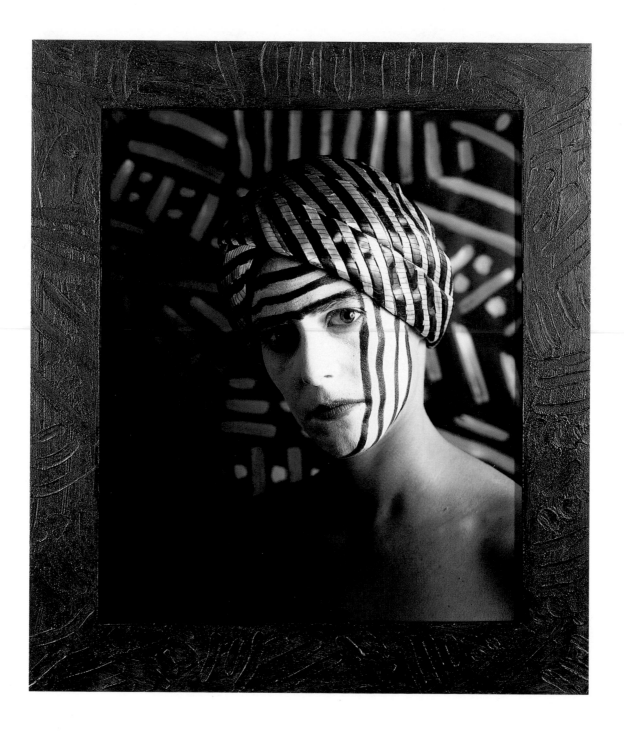

Persona X

PLATE

24

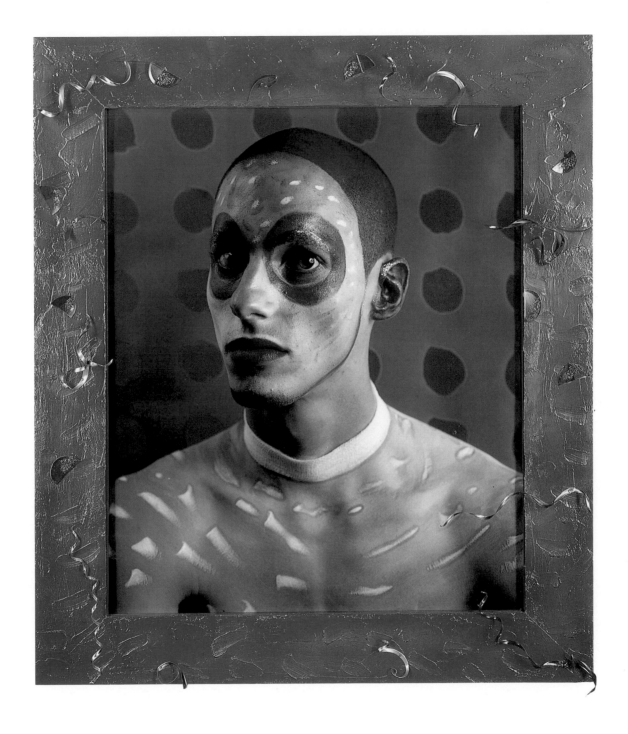

Persona XI

PLATE

25

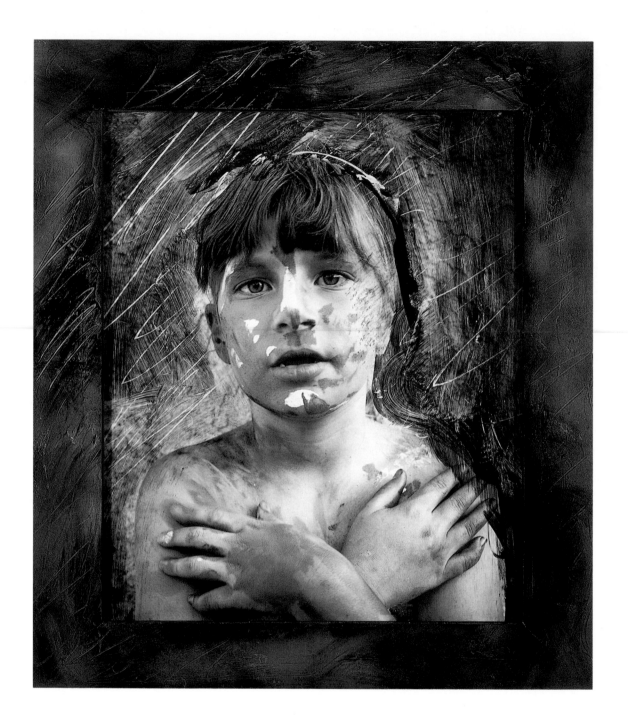

Persona XV

PLATE

26

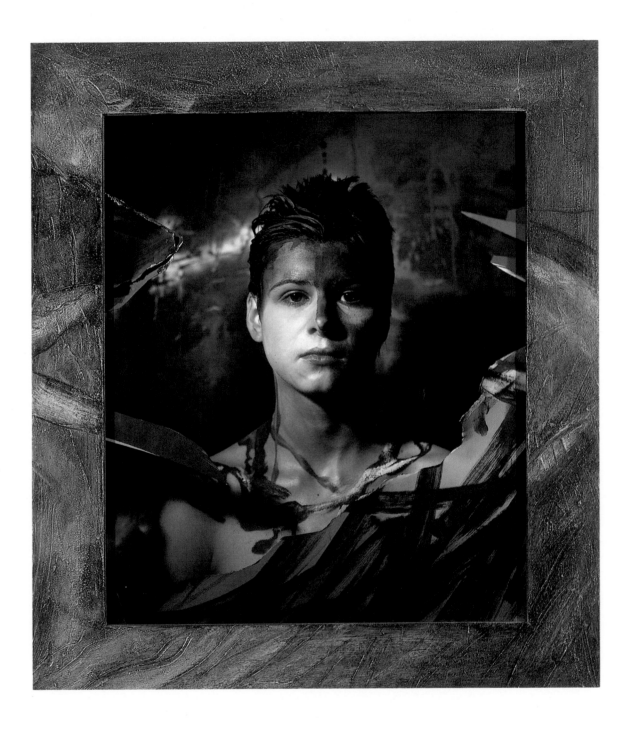

Persona XIII

PLATE

27

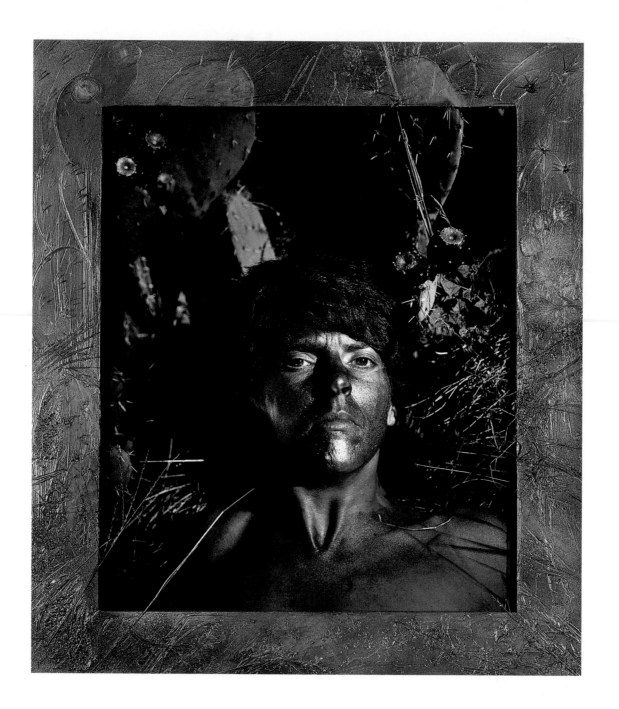

Cycles VIII

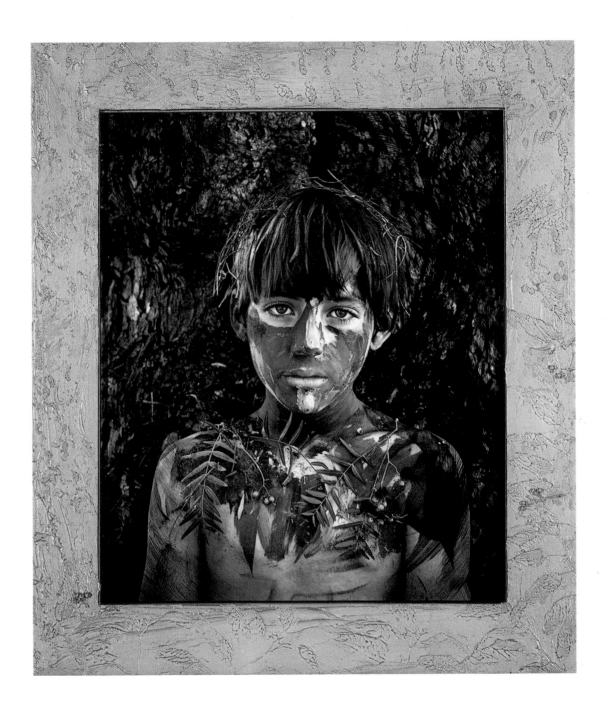

Cycles V

PLATE

29

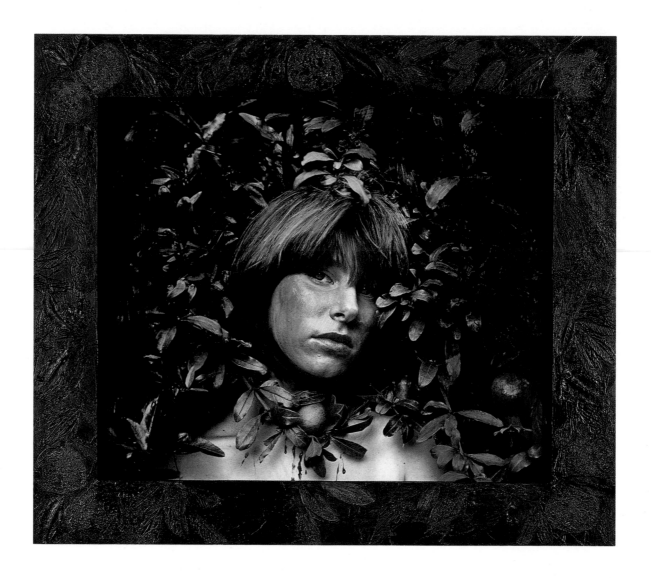

Cycles VII

PLATE

30

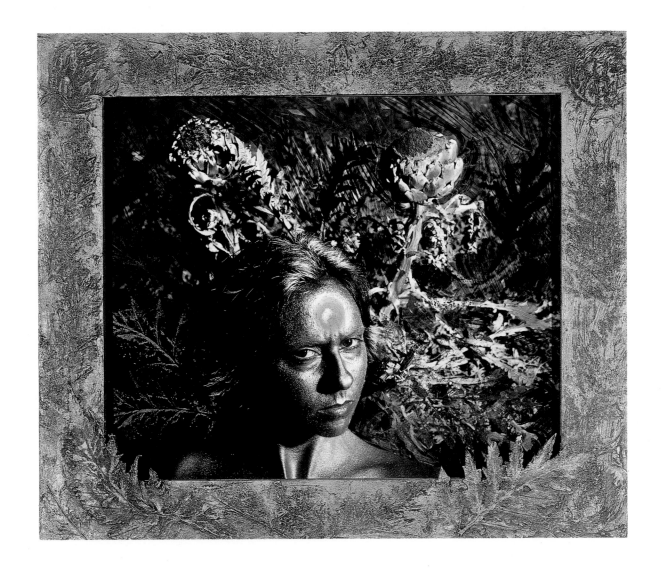

Cycles VI

PLATE

31

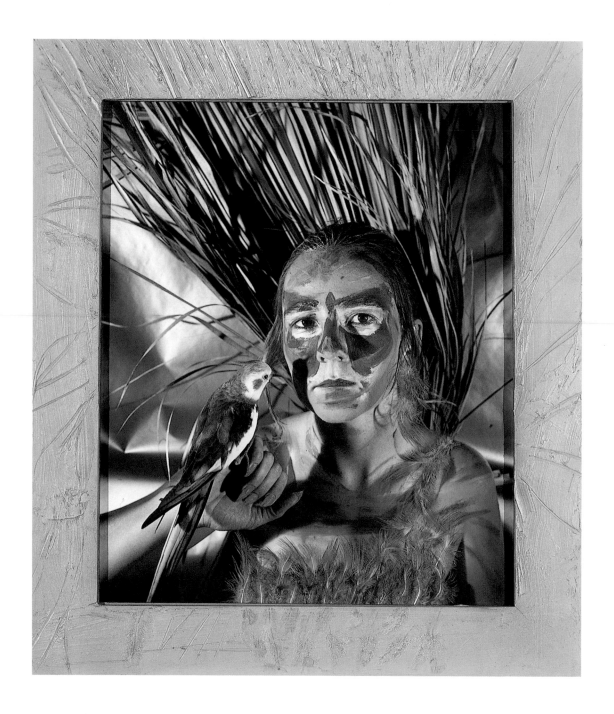

Cycles X

PLATE

32

1934 Born Judith Greene, in Chicago, Illinois.

1952 Received art scholarship; enrolled at Indiana University.

1954 Continued studies at Washington University, St. Louis, through 1955.

1956 Returned to Chicago. Worked as graphic designer.

1967 Began to attend the School of the Art Institute of Chicago, part-time.

1972 Completed *Cycles*, first major body of photographic work. Began an investigation and production of hand-made artist's books, which incorporate many of the same techniques of coloring and collage that are integral to her photographs and are also directly related to the content of her photographic work. Bookmaking interest continues throughout other projects.

1973 Received BFA degree from School of the Art Institute of Chicago; moved to Northern California to pursue graduate work at the University of California, Davis.

1974 Began work on *Chameleon* series, completed the following year.

1975 Received MFA degree from University of California, Davis; moved to Los Angeles to teach at UCLA. Began work on *Magazine* series.

1976 *Magazine* series evolved into *Magazine Makeovers*. Began work on *People Magazine* series, which continued through 1978. Was one of eleven artists included in The Friends of Photography's traveling exhibition *Emerging Los Angeles Photographers*.

1977 Began *Ode to Hollywood* series, which continued into following year.

1979 Moved to San Francisco; taught photography at University of California, Davis, and at the California College of Arts and Crafts in Oakland. Received an Individual Photographer's Fellowship from the National Endowment for the Arts. Completed *Forbidden Fantasies*.

1980 Began *Portraits of Women*, which continued through 1981.

1981 Moved to Tucson; joined faculty of the University of Arizona.

1982 Completed *Relationships* series. Began work on *Persona* project, which continued through 1985.

1983 Began work on a new *Cycles* series. Received grant from the Polaroid Corporation.

1984 Received Individual Artist's Fellowship from the Arizona Commission for the Arts, as well as a grant from the Arizona Foundation in Tucson. Began *Elements* project, completed in 1985 and reworked in 1986.

1986 Retrospective exhibition at the Museum of Photographic Arts, San Diego.

1987 Continues work on *Cycles* series as well as on further photographic explorations. Exhibition of recent photographs at The Friends of Photography Gallery, Carmel.

Selected one-person exhibitions

1977 University of California, San Francisco
School of the Art Institute of Chicago
G. Ray Hawkins Gallery, Los Angeles

1979 Quay Gallery, San Francisco

1980 A. Nagel Galerie, Berlin, West Germany

1981 San Francisco Museum of Modern Art
Quay Gallery, San Francisco

1982 Catskill Center for Photography, Woodstock, New York

1983 Center for Creative Photography, University of Arizona, Tucson

1984 Photography at Oregon Gallery, University of Oregon Museum of Art, Eugene

1985 Etherton Gallery, Tucson
Andover Gallery, Andover, Massachusetts
Colburg Gallery, Vancouver, British Columbia

1986 Museum of Photographic Arts, San Diego (retrospective)

1987 The Friends of Photography, Carmel
Tucson Museum of Art (retrospective)
University Art Museum, University of New Mexico, Albuquerque (retrospective)

Selected group exhibitions

1977 Seattle Art Museum, *Modern Photography*.

Fogg Art Museum, Harvard University, Cambridge, *Contemporary Photography*.

The Friends of Photography, Carmel, *Emerging Los Angeles Photographers* (traveled).

1978 University Art Museum, University of New Mexico, Albuquerque, *20th Century Photography, 1959–present*.

1979 Light Gallery, New York City, *Four California Photographers*.

Santa Barbara Museum of Art, Santa Barbara, California, *Attitudes: Photography in the 1970s*.

Herbert F. Johnson Museum of Art, Cornell University, Ithaca, New York, *Translation: Photographic Images with New Forms*.

1981 Vienna Secession, Vienna, Austria, *International Biennale Erweiterte Fotografie*.

Centre National d'Art et de Culture George Pompidou, Paris, *Auto Portraits Photographiques 1898–1981*.

Arts Council of Great Britain. *The Photographer as Printmaker* (traveled).

De Saisset Museum, University of Santa Clara, Santa Clara, California, *Contemporary Hand Colored Photographs*.

1982 San Francisco Museum of Modern Art, *Collage and Assemblage*.

1983 Museum of Photographic Arts, San Diego, *Big Pictures* (traveled).

Contemporary Arts Museum, Houston, *Photographic Collage*.

1984 Tucson Museum of Art, *Tucson Biennial*.

Institute of Contemporary Art, University of Pennsylvania, Philadelphia, *Face to Face; Recent Portrait Photography*.

San Francisco Museum of Modern Art, *Photography in California, 1945–1980* (traveled).

University Art Museum, University of New Mexico, Albuquerque, *The Self as Subject: Visual Diaries of 14 Photographers*.

1985 Phoenix Art Museum, Phoenix, *Phoenix Biennial*.

San Francisco Museum of Modern Art, *Extending the Perimeters of 20th Century Photography*.

San Francisco Museum of Modern Art, *Signs of the Times*.

1986 National Portrait Gallery, London, *Self Portrait Photography, 1840–1985* (traveled).

San Francisco Museum of Modern Art, *Photography: A Facet of Modernism*.

Museum of Fine Art, Santa Fe, *Poetics of Space*.

Tucson Museum of Art, *Arizona Biennial*.

1987 Los Angeles County Museum of Art, *Photography and Art, 1946–1986*

Selected Collections

Art Institute of Chicago

California Museum of Photography, University of California, Riverside

Center for Creative Photography, University of Arizona, Tucson

Fogg Art Museum, Harvard University, Cambridge

George Eastman House, Rochester, New York

Los Angeles County Museum of Art

Minneapolis Institute of Arts

Museum of Modern Art, New York City

Museum of Photographic Arts, San Diego

Newport Harbor Art Museum, Newport Beach, California

Oakland Museum, Oakland, California

The Polaroid Collection, Cambridge

San Francisco Museum of Modern Art

University Art Museum, University of New Mexico, Albuquerque

University of California, Davis

Wight Gallery, University of California, Los Angeles

Publications

Albright, Thomas. "Rogue's Gallery of Decadent Chic." *San Francisco Chronicle*, September 26, 1981.

Cohen, Joyce Tenneson. *In/Sights: Self-Portraits by Women*. Boston: David Godine, Publisher, 1978.

Coke, Van Deren, with Diana C. du Pont. *Photography, A Facet of Modernism*. New York: Hudson Hills Press, 1986.

Editors of Time-Life Books. "Discoveries: Judith Golden's Serious Masquerades." *Time-Life Photography Annual*. New York: Time-Life Books, 1978.

Fahey, David. "Interview: Judith Golden." *The G. Ray Hawkins Photo Bulletin*, August/September 1978.

Fischer, Hal. "Judith Golden." *Artforum*, January 1982.

_____. "California Photography: The Tradition Beyond Modernism." *Studio International*, June 1982.

Gauss, Kathleen McCarthy, and Andy Grundberg. *Photography and Art, Interactions since 1946*. New York: Abbeville Press, 1987.

The Friends of Photography. *Emerging Los Angeles Photographers (Untitled 11)*. Carmel: The Friends of Photography, 1976.

Hedgepeth, Ted. "Forbidden Fantasies." *Artweek*, October 27, 1979.

Katzman, Louis. *Photo/Trans/Form*. San Francisco: San Francisco Museum of Modern Art, 1981.

_____. *California Photography, 1945–1980*. San Francisco: San Francisco Museum of Modern Art, 1984.

McMann, Jeanne. "Painting & Photograhpy: Judith Golden." *Camerawork*, Spring 1984.

Murray, Joan. "Two Female Perspectives at Variance." *Artweek*, September 26, 1981.

_____. "Judith Golden's Explorations of Self." *Artweek*, March 26, 1977.

Ollman, Arthur. "Judith Golden, Uncovering through Disguise." San Diego: Museum of Photographic Arts, 1986.

Portner, Dinah. "Judith Golden's Self Portrait Fantasies." *Artweek*, September 16, 1978.

_____. "Dialogue with Judith Golden." *Los Angeles Center for Photographic Studies Newsletter*, October 1978.

Reich, Sheldon. "Judith Golden: The Chameleon, the Personal, the Cycles." *Artspace*, Winter 1986–1987.

Wise, Kelly. "Judith Golden Exhibit a Knockout." *Boston Globe*, May 12, 1985.

Printed in Japan